JACK BENDER

I AM
SORRY

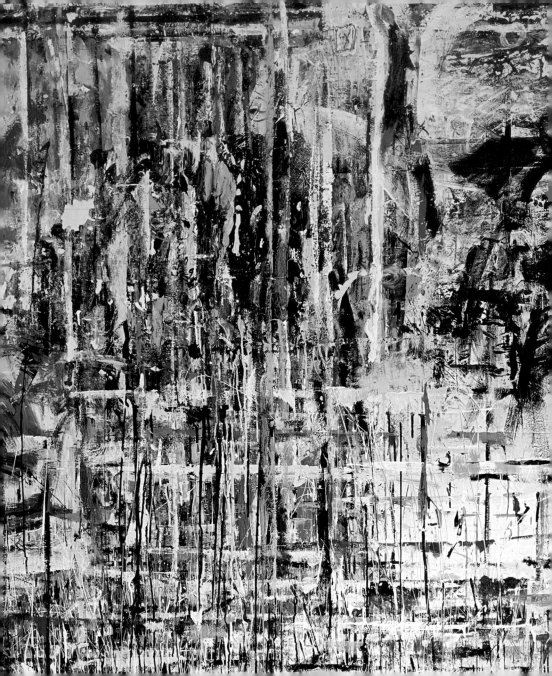

JACK BENDER

I AM
SORRY

ART AND
APOLOGIES

FLASH POINT

A multitude of gratitude to all those who helped
And to BEC TAGGART
Can't say I am sorry for all the versions . . .
JB

———————————

Published by Flashpoint™ Books, Seattle
www.flashpointbooks.com

Produced by Girl Friday Productions

Design: Paul Barrett
Development & editorial: Kristin Duran
Production editorial: Laura Dailey

ISBN (hardcover): 978-1-959411-32-1
ISBN (ebook): 978-1-959411-20-8

Library of Congress Control Number: 2023902343

First edition

For my dear friend John Ritter, who always showed up with his brilliant talent, wearing his heart on his sleeve

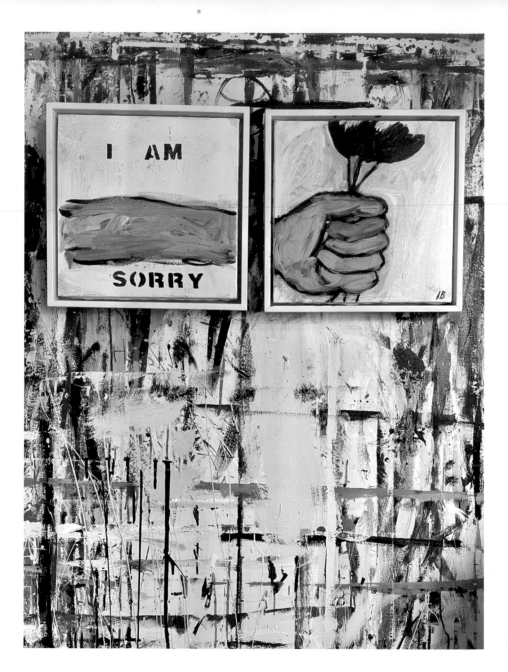

I AM SORRY.

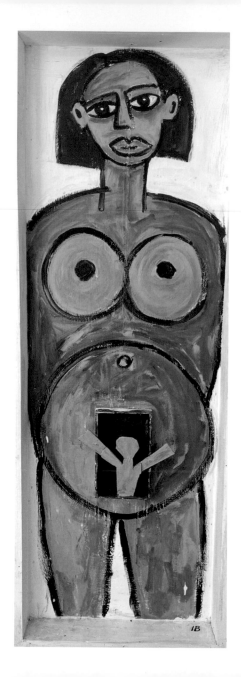

I'M SORRY
THE WORLD I
BROUGHT YOU
INTO ISN'T A
BETTER PLACE.

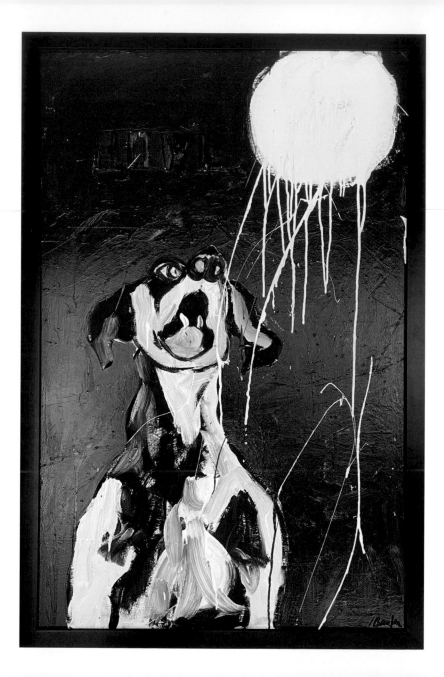

I'M SORRY MY
LATE-NIGHT
CONVERSATIONS
KEPT YOU UP.

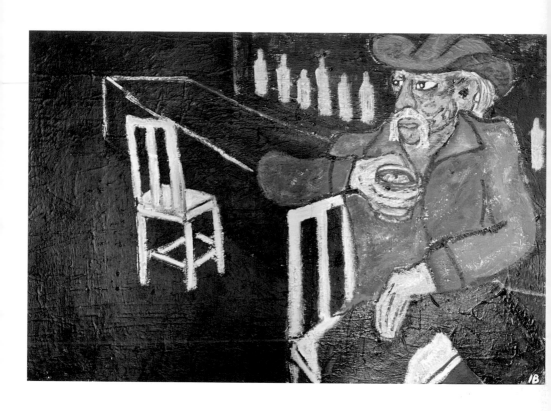

I'M SORRY I
NEVER ASKED
YOU TO DANCE.

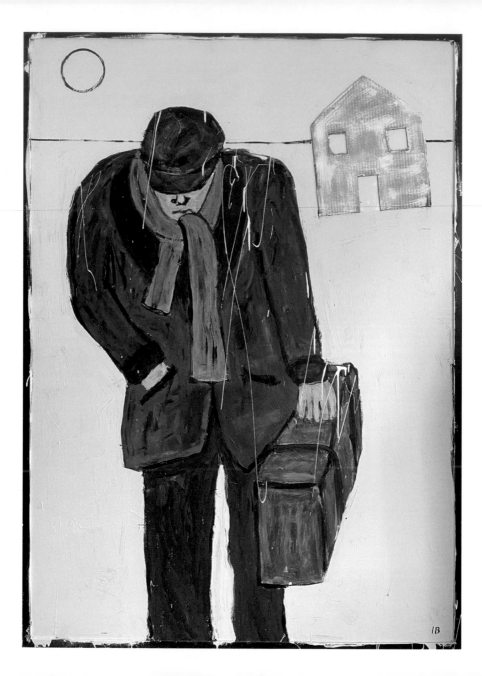

I'M SORRY I LEFT WITHOUT SAYING GOODBYE.

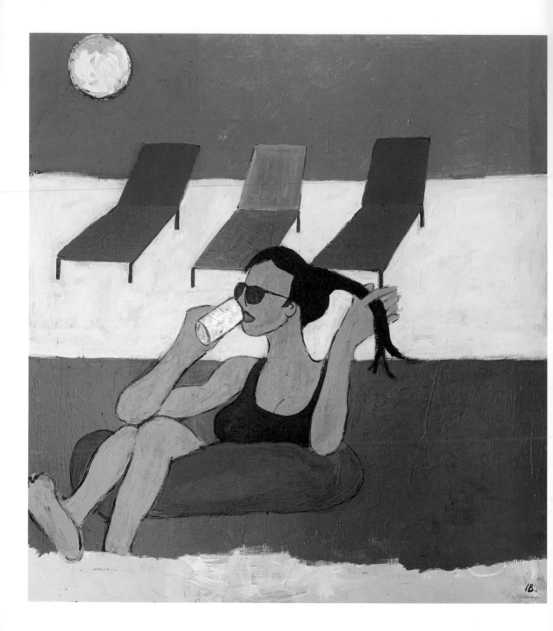

I'M SORRY YOU SPENT ALL THAT MONEY ON REHAB.

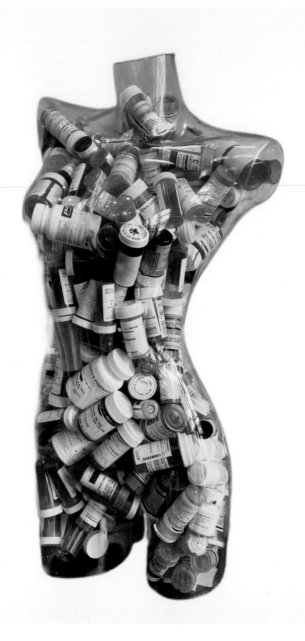

I'M SORRY I
STILL FEEL
EMPTY.

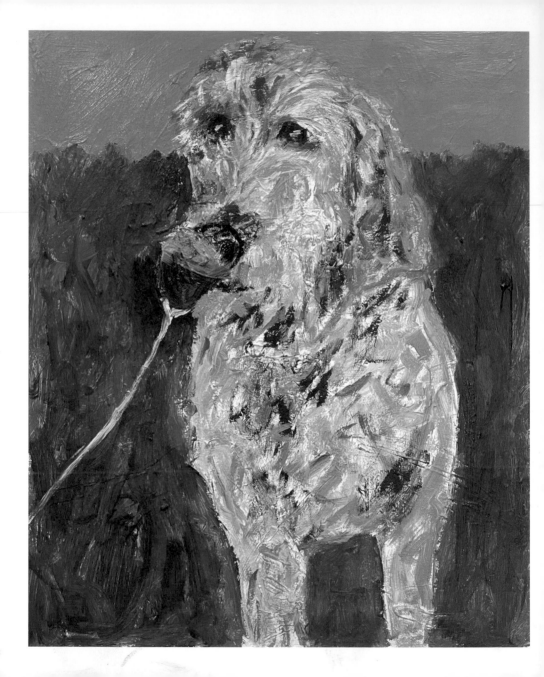

I'M SORRY I
ALWAYS HAD
TO STOP TO
SMELL THEM.

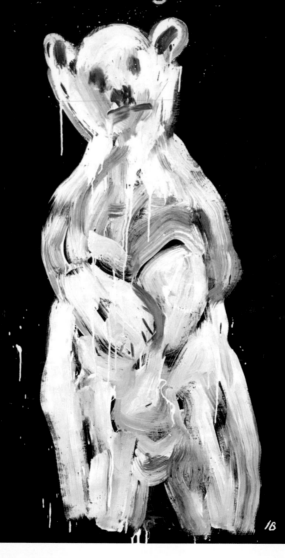

I'M SORRY
WE COULDN'T
CONVINCE YOU.

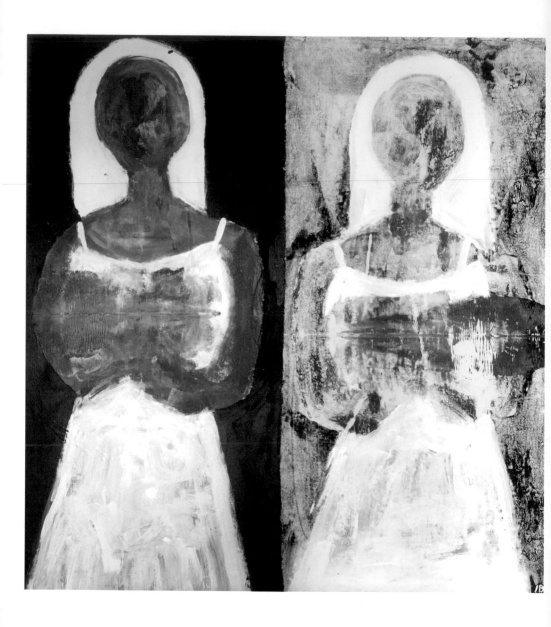

I'M SORRY
I SAID I DO
WHEN I DIDN'T.

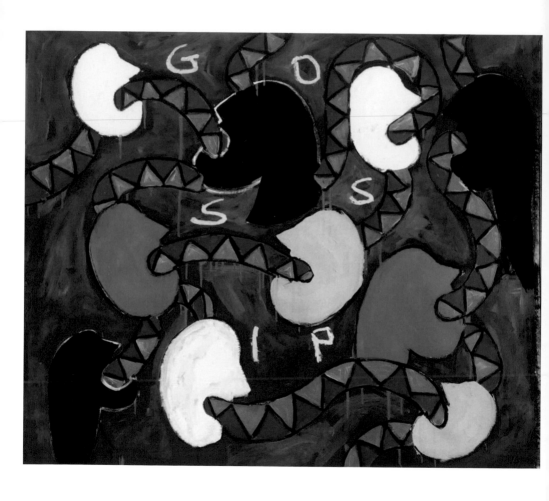

I'M SORRY I
SPREAD THOSE
RUMORS
ABOUT YOU.

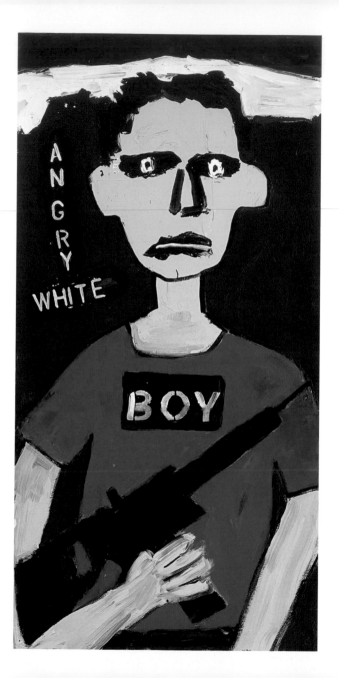

I'M SORRY I GOT
IT SO WRONG.

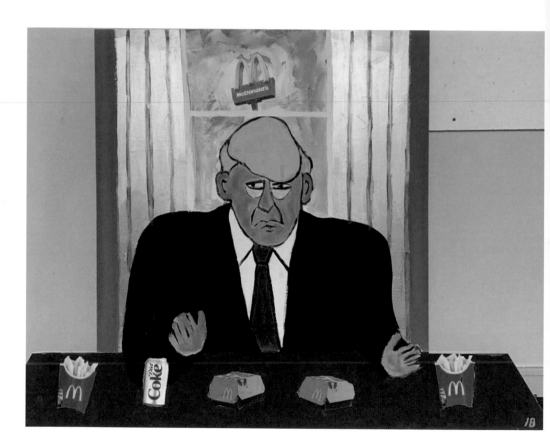

SORRY NOT SORRY, NOTHIN' TO APOLOGIZE FOR.

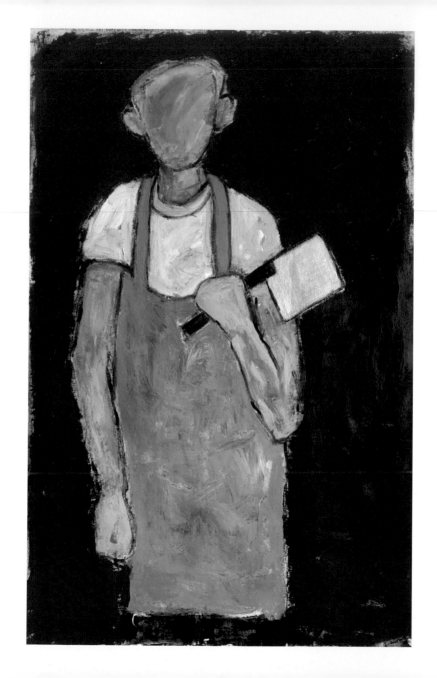

I'M SORRY IT
WASN'T ALWAYS
KOSHER.

WOMAN
AND THE
CRYING
MOON
DURING
PAN-
DEMIC

JB

I'M SORRY I
ONLY SAW
YOU WITH A
MASK ON.

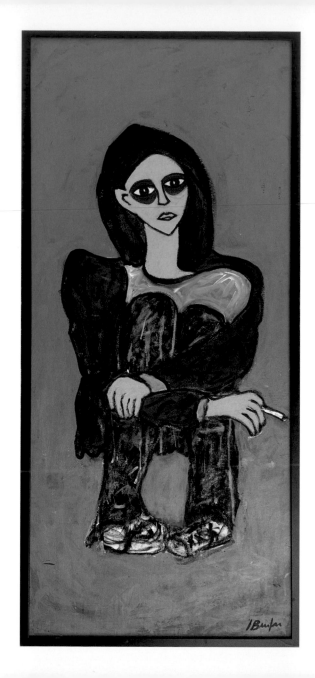

I'M SORRY FOR
ALL THE BROKEN
CURFEWS.

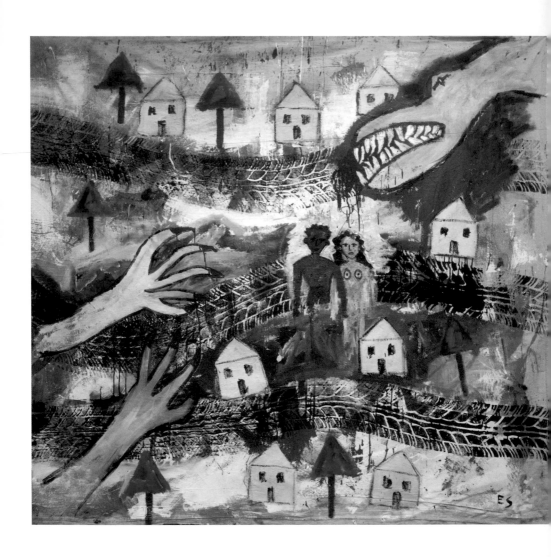

I'M SORRY
I COULDN'T
PROTECT YOU
FROM YOUR
NIGHTMARES.

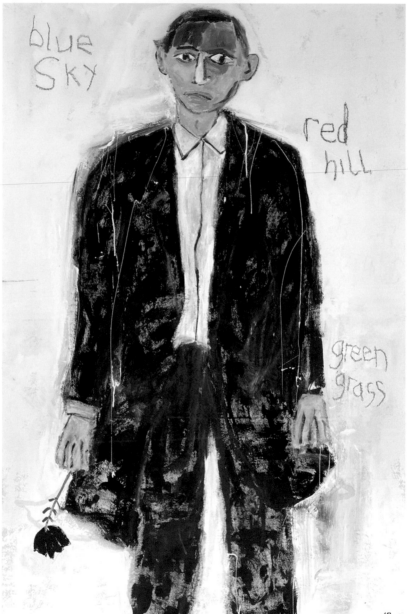

blue
Sky

red
hill

green
grass

1B

I'M SORRY
I THOUGHT
THE GRASS
WAS ALWAYS
GREENER.

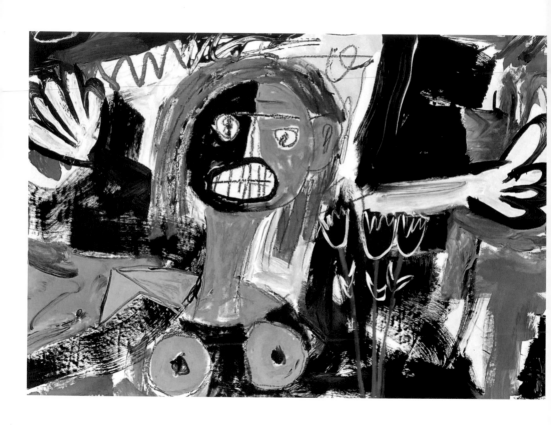

I'M SORRY I BIT
THE DENTIST.

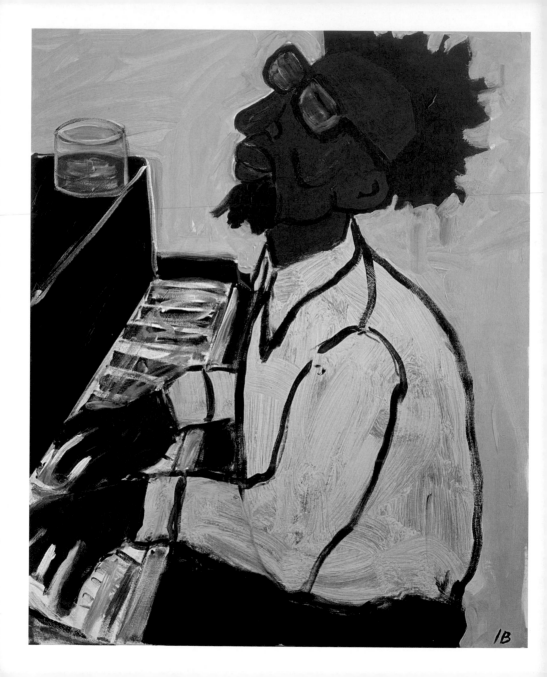

I'M SORRY I'M
ONLY IN THE
PINK WHEN
I'M PLAYING
THE BLUES.

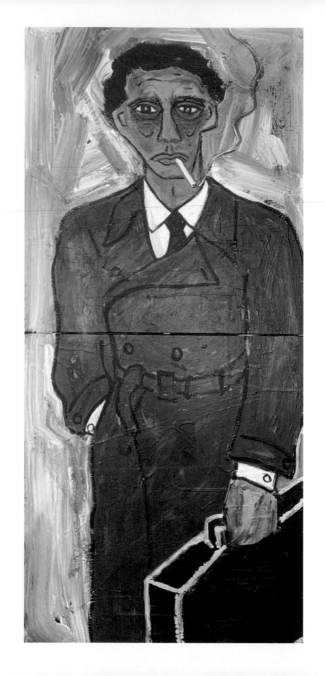

I'M SORRY
I WASN'T
SO GOOD
AT KEEPING
SECRETS.

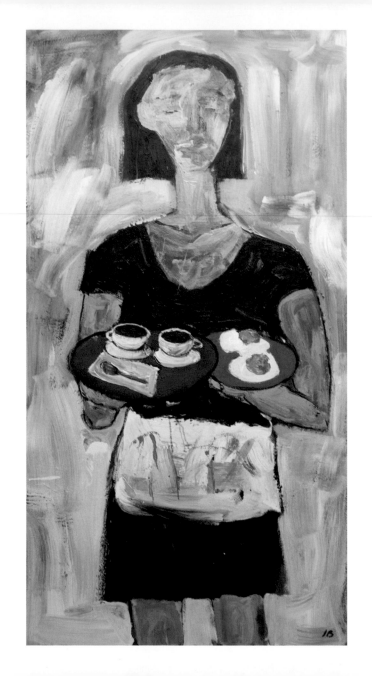

I'M SORRY, BUT
YOU DEFINITELY
SAID SUNNY-
SIDE UP.

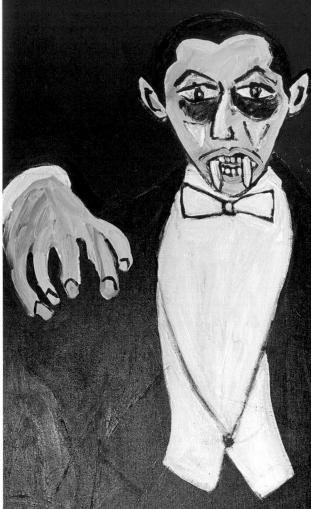

MOVIE STAR

IB

I'M SORRY I
DIDN'T DO MORE
COMEDIES.

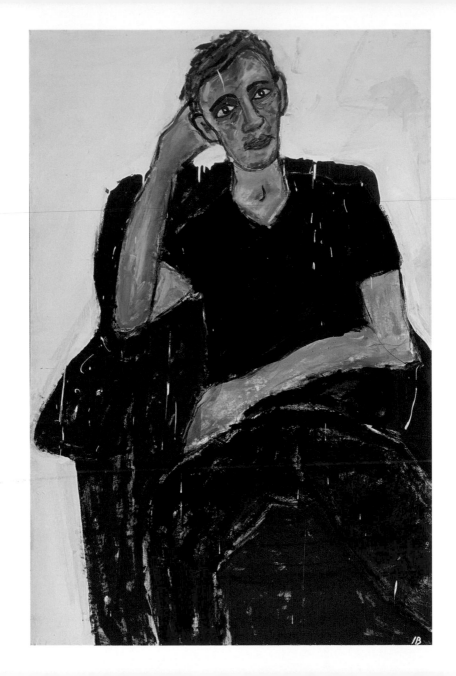

I'M SORRY
I NEVER
WANTED TO GO
ANYWHERE.

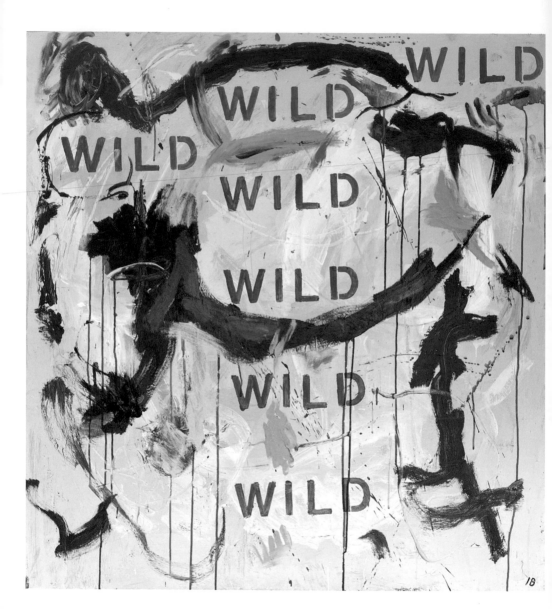

I'M SORRY
I TRIED TO
TAME YOU.

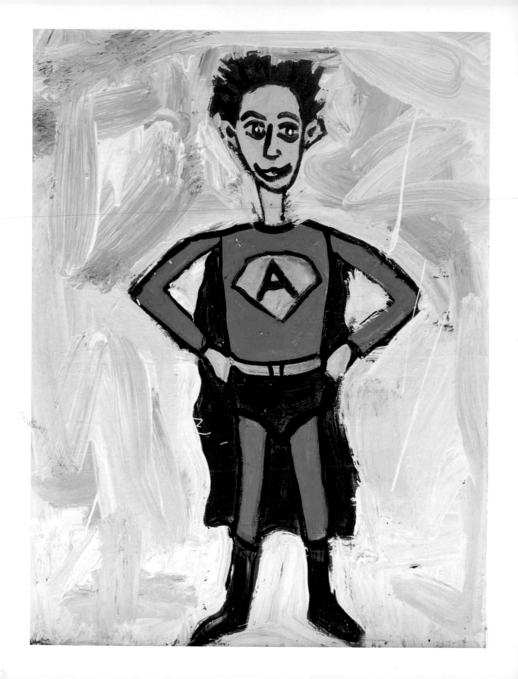

I'M SORRY I PRETENDED TO BE MORE THAN AVERAGEMAN.

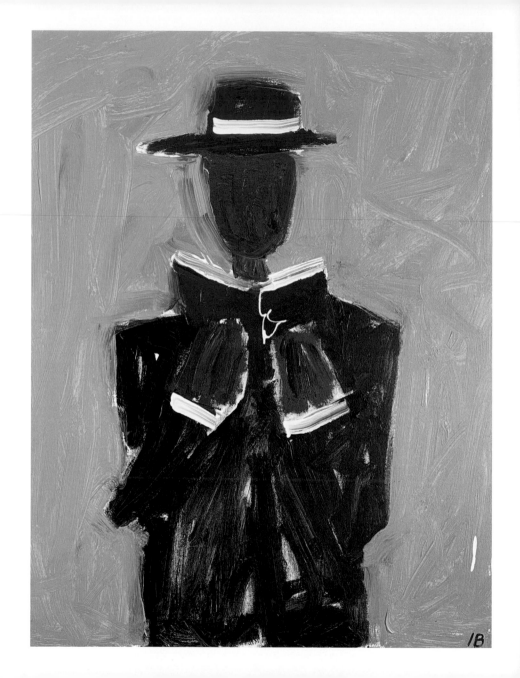

I'M SORRY IF MY PRAYERS WEREN'T ENOUGH.

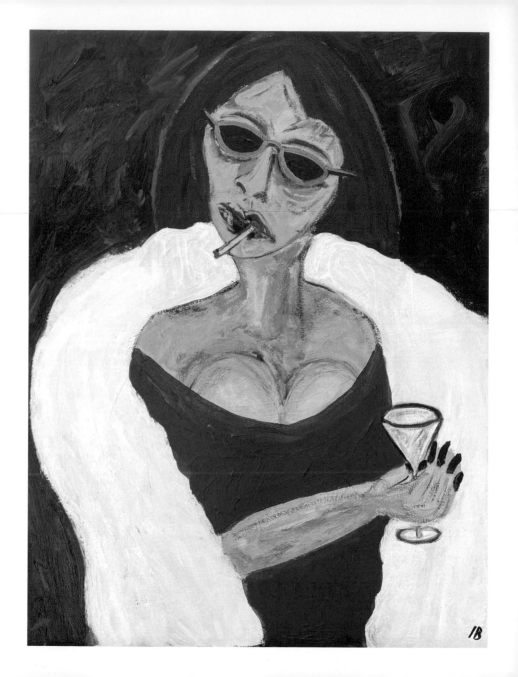

I'M SORRY I
STAYED AT
THE PARTY
TOO LONG.

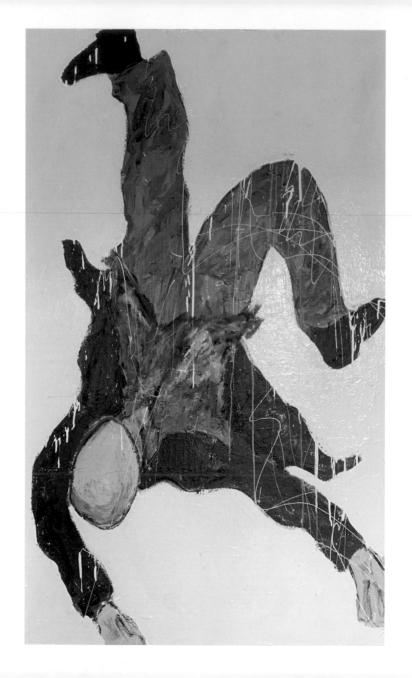

I'M SORRY
I COULDN'T
HOLD ON.

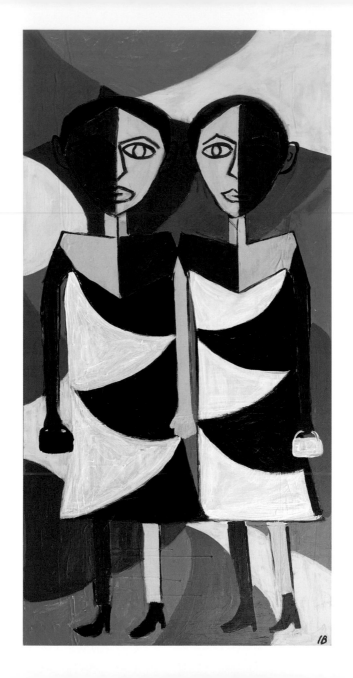

I'M SORRY I BROUGHT MY SISTER ON ALL OUR DATES.

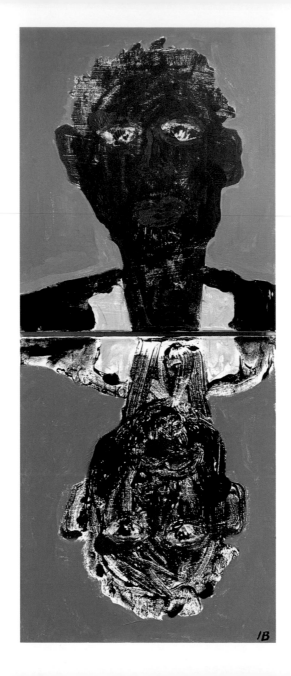

I'M SORRY I
DIDN'T SHOW
YOU MY
BEST SIDE.

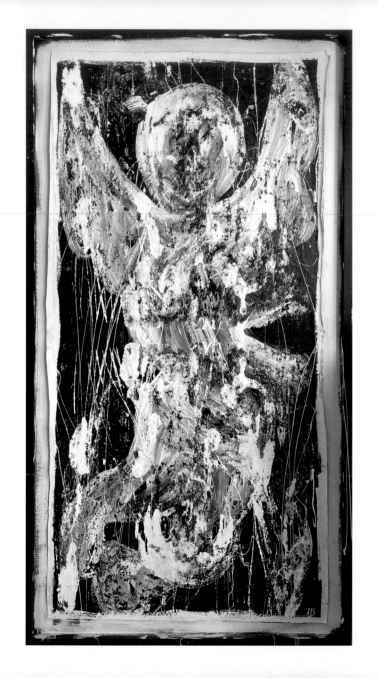

I'M SORRY I'M
NOT A PERFECT
ANGEL.

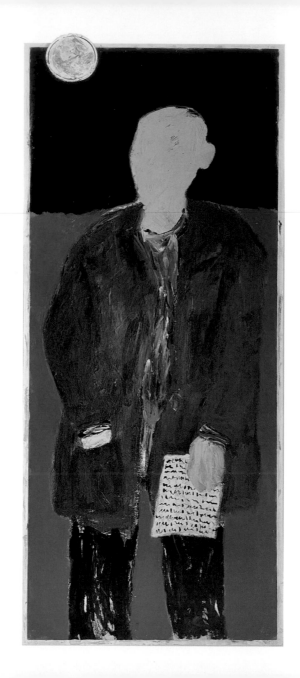

I'M SORRY I
NEVER SENT
THE LETTER.

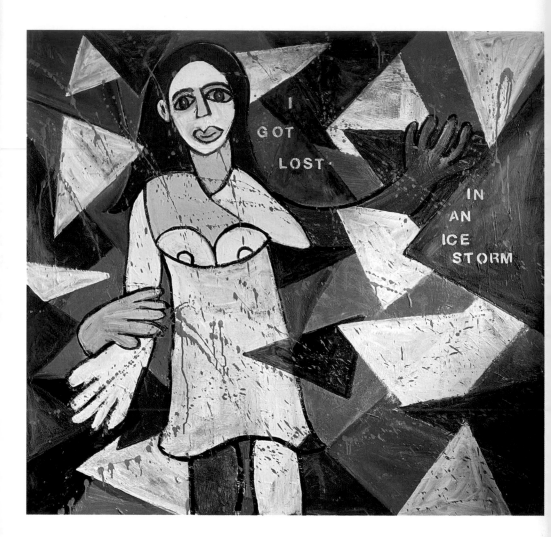

I'M SORRY I
ALWAYS LIKED
TO FIND MY
OWN WAY.

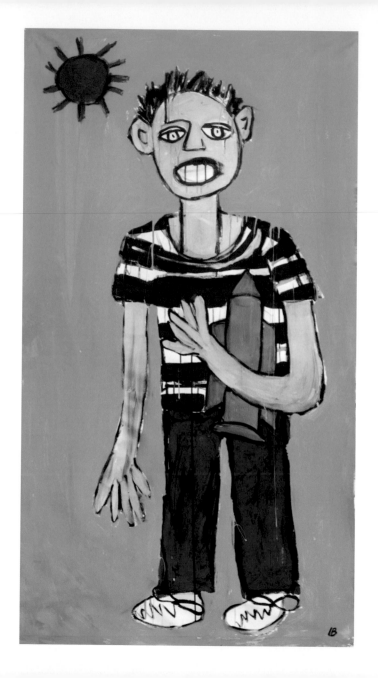

I'M SORRY
GROWN-UPS
INVENTED
NUKES.

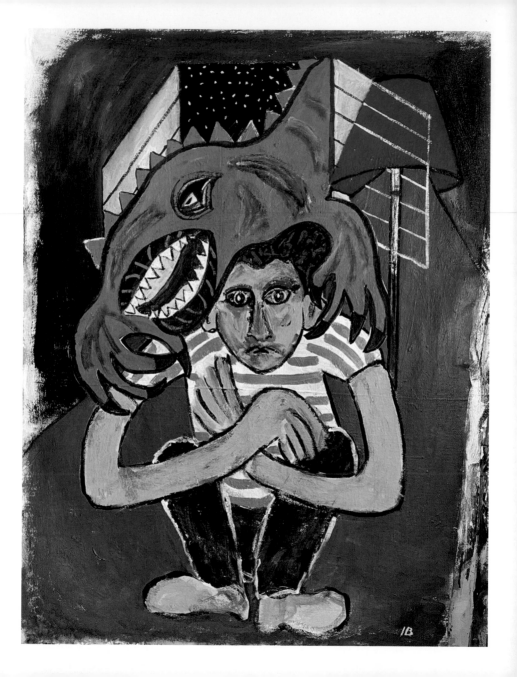

I'M SORRY I
HAD SUCH AN
OVERACTIVE
IMAGINATION.

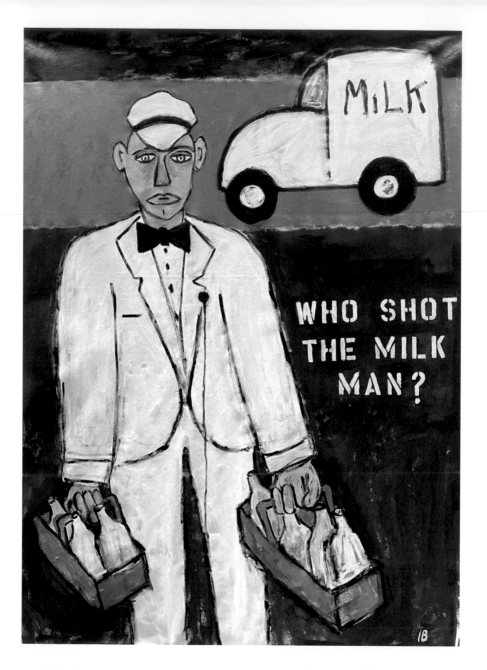

I'M SORRY
I FORGOT YOU
WERE LACTOSE
INTOLERANT.

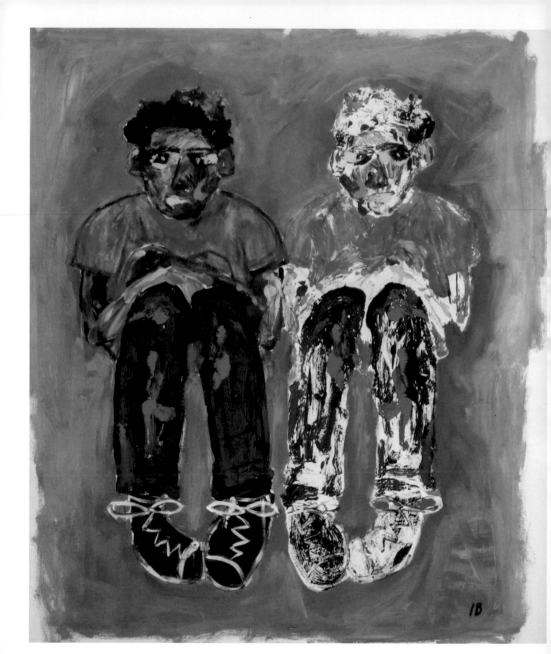

I'M SORRY I
BLAMED THE
OTHER GUY.

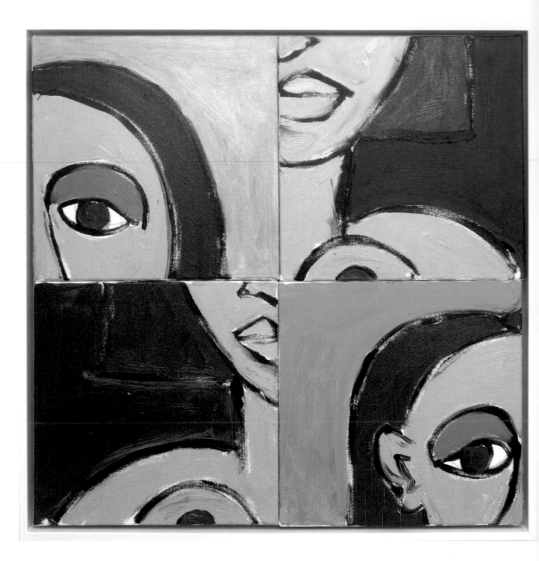

I'M SORRY I
NEVER MAKE
SENSE.

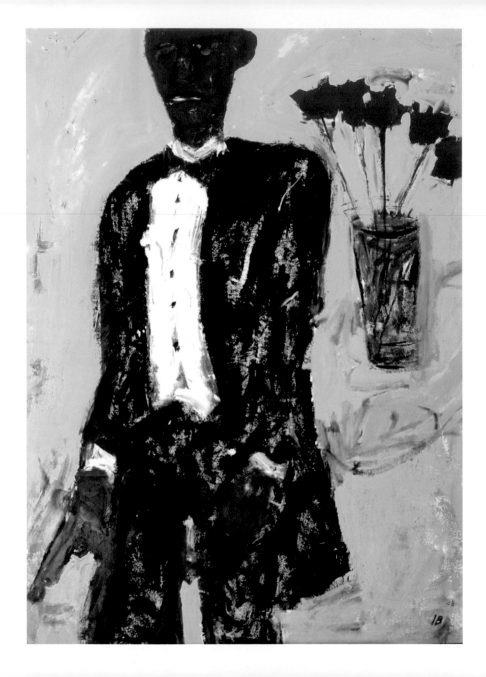

I'M SORRY I MISSED THE FATHER-DAUGHTER DANCE.

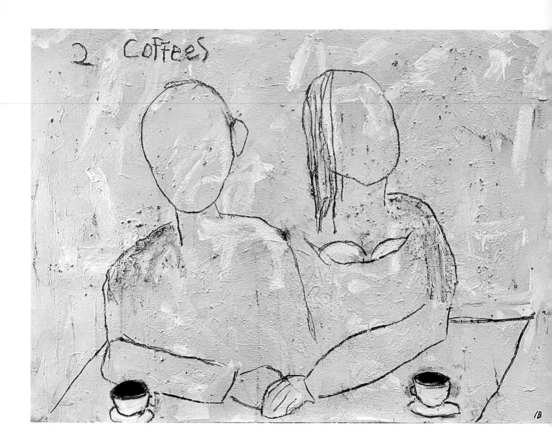

I'M SORRY IT
WAS ONLY ONE
COFFEE DATE.

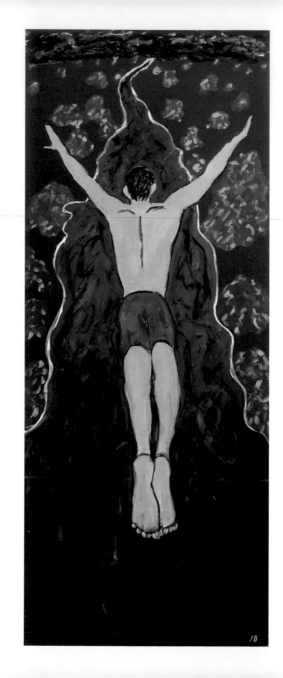

I'M SORRY I
LOVE MY LIFE
THE MOST WHEN
I'M RISKING IT.

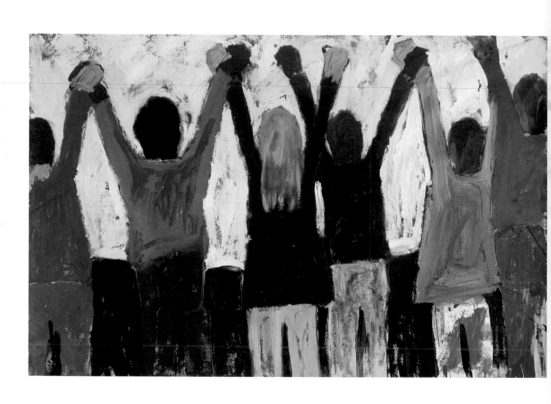

I'M SORRY
YOU DON'T
LIKE WHAT WE
STAND FOR.

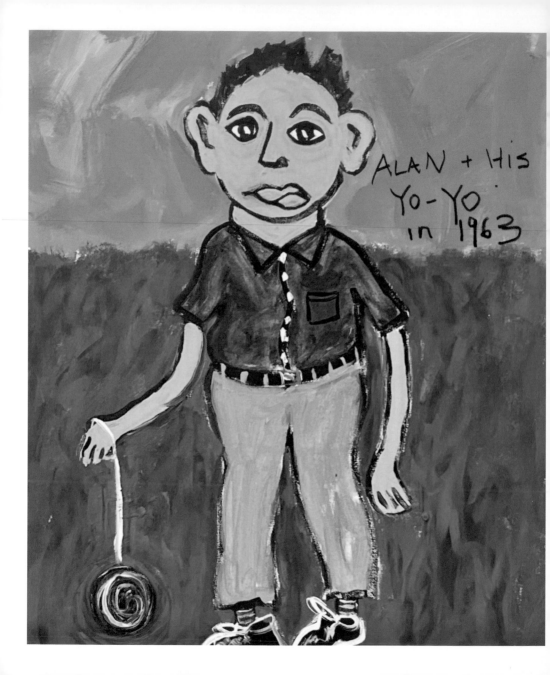

ALAN + HIS
YO-YO
in 1963

I AM SO SORRY . . .

A yo-yo was Alan's constant companion, his best friend. He could make it do tricks, like "walking the dog" or "rocking the baby." I'm sure it made him happy because he could control it, but Alan couldn't control how his classmates treated him. I was part of the popular crowd and would frequently make my friends laugh by imitating Alan or making him the punch line of our infantile jokes.

We all had our "yo-yos" to help get us through the challenging obstacle course of childhood. One of mine was getting laughs, but when I did so at Alan's expense, inside I felt more like him than I could admit.

Leonard Cohen once said to me, "We shouldn't put anxiety in the hearts of others." Looking back, that's exactly what I was doing to Alan. For that I am sorry. Like me, all the characters in this book are apologizing to someone for what they did or didn't do.

We are living through a very dark, difficult time, dealing with huge

global issues that frequently seem beyond our control. But maybe, like Alan with his yo-yo, we can all do small things to get through tough times and make our tiny piece of this world better.

My hope for this book is that it gives you some laughs and a bit of a loving nudge to say those three simple words, "I AM SORRY," to someone who might need to hear them.

—Jack Bender
Los Angeles, 2023

ABOUT THE AUTHOR

JACK BENDER is a lifetime painter and all-around creative force who brings a unique vision to the canvas. He uses painting and sculpture as storytelling mediums through which he explores the intersection of spirituality, pop culture, and contemporary life in ways that are both intellectually provocative and emotionally and visually stimulating. His works are intensely personal and raw.

Jack grew up in Los Angeles, climbing roofs in his neighborhood,

going from house to house without ever having to touch the ground. To him, it was a Southern California Chagall dream.

He began studying painting at the age of fourteen with renowned California painter Martin Lubner. After studying fine art, drama, and cinema at the University of Southern California, Jack directed regional theatre before beginning his career in television and becoming one of the most celebrated director-producers in TV. He directed numerous TV movies, and his episodic work includes *Felicity*, *Alias*, *Ally McBeal*, *Carnivàle*, and *The Sopranos*. As executive producer/director, Jack was one of the lead creative forces behind the worldwide hit show *Lost*. Many of his original artworks were used in the show, including the iconic *Hatch* painting. Under his direction, *Lost* won Outstanding Drama Series at the 57th Annual Primetime Emmy Awards and Best Television Series (Drama) at the 63rd Annual Golden Globe Awards.

Jack directed and executive-produced three seasons of *Mr. Mercedes*, the critically acclaimed series based on Stephen King's award-winning trilogy, for DirecTV/Audience Network and Peacock. He was honored to be asked to direct the Leonard Cohen tribute concert *Tower of Song* in Montreal. It was filmed and has been seen worldwide. One of his recent projects, MGM+'s series *From*, premiered its second season in April 2023. He is currently developing a new series based on Stephen King's bestseller *The Institute*.